COLLECTING GAUGUIN
SAMUEL COURTAULD IN THE '20s

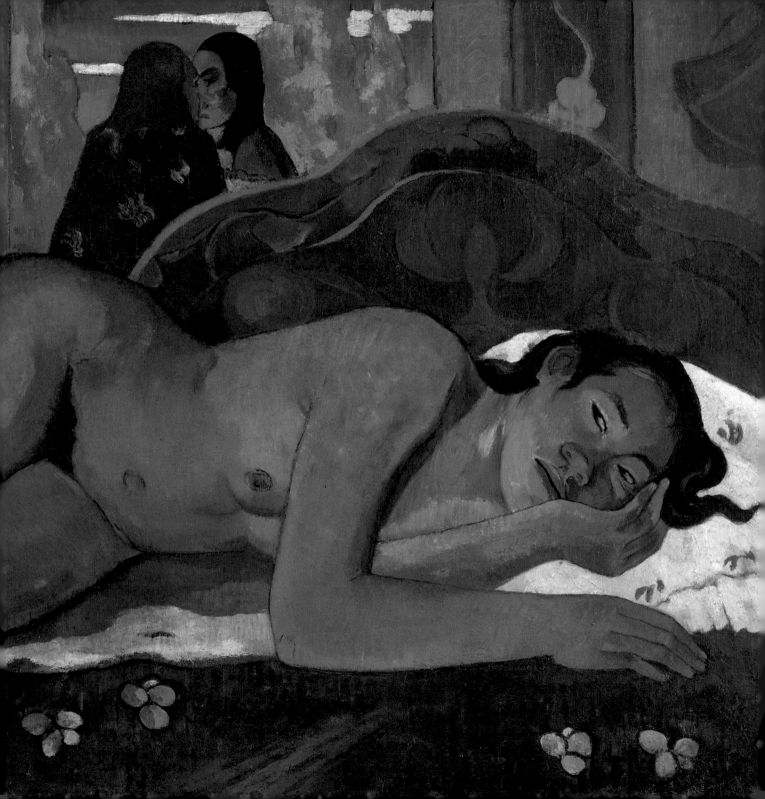

COLLECTING GAUGUIN
SAMUEL COURTAULD IN THE '20S

Karen Serres

THE
COURTAULD
Gallery

First published to accompany the display

COLLECTING GAUGUIN
SAMUEL COURTAULD IN THE '20s

The Courtauld Gallery, London
20 June – 8 September 2013

ISBN 978 1 907372 47 6

British Library Cataloguing in Publication Data

A catalogue record for this book is available from the British Library

Produced by Paul Holberton publishing
89 Borough High Street, London SE1 1NL
www.paul-holberton.net

Designed by Laura Parker
www.parkerinc.co.uk

Origination and printing by
E-graphic, Verona, Italy

FRONT COVER detail, cat. 4
FRONT FLAP detail, cat. 10
BACK FLAP detail, cat. 8
PAGE 2 detail, cat. 3

PHOTOGRAPHIC CREDITS

All images © The Samuel Courtauld Trust, The Courtauld
Gallery, London, except cat. 1, fig. 13: © Scottish National Gallery,
Edinburgh; cat. 5 © The Barber Institute of Fine Arts, University of
Birmingham; fig 2 © akg/De Agostini Pic.Lib.; fig. 8 © Ordrupgaard,
Copenhagen. Photo: Pernille Klemp; fig. 10 © Metropolitan
Museum of Art, Art Resource NY / Scala, Florence; figs. 11, 12
© RMN-Grand Palais (musée d'Orsay) / Hervé Lewandowski

CATALOGUE NOTES

All works are by Paul Gauguin (1848–1903) except cat. 19.

Measurements are always noted height x width x depth
(where appropriate).

PROVENANCE Dealers' names are indicated in brackets to
distinguish them from private collectors.

EXHIBITIONS Only early and key recent exhibitions are included.

FOREWORD

Collecting Gauguin: Samuel Courtauld in the '20s inaugurates a new series of special displays at The Courtauld Gallery. Entitled 'Summer Showcase', this programme is intended to provide an opportunity to focus attention on selected aspects of the Gallery's exceptional permanent collection. It differs from our main exhibition programme in that it will only rarely feature loans and will be accompanied by a new publication format, for which this attractive and highly informative volume sets the template.

It seems very appropriate that in the 80th anniversary of The Courtauld Institute of Art we should take as our subject the collection of one of our founders. In the 1920s, the industrialist Samuel Courtauld assembled one of Europe's most important holdings of Impressionist and Post-Impressionist art. Alongside his private collection, the majority of which is now housed in The Courtauld Gallery, Samuel Courtauld also funded and directed a programme of major acquisitions for the National Gallery as a deliberate contribution to public life and widespread appreciation of the arts. Courtauld's acquisitions of works by the Post-Impressionist master Paul Gauguin provide an interesting thread through this decade. They do not reflect the same level of intuitive and deeply personal engagement evident in the formation of his great holdings of paintings and works on paper by Cézanne. Nor, indeed, was Gauguin as pivotal as Cézanne in the bruising debates about modern art that provided the backdrop for Courtauld's purchases and informed his purposes as a collector. Nevertheless, Gauguin was clearly an essential figure in Courtauld's appreciation of 'the modern movement' and the collection of this artist's work he presented to the Gallery is unerring in its quality.

Paintings such as *Te Rerioa* and *Nevermore* are without doubt amongst the artist's masterpieces. This publication presents Samuel Courtauld's collection of Gauguins as it briefly stood in 1929, at the end of his single concentrated decade of collecting. Unusually, Courtauld subsequently sold two of his paintings by the artist: *Martinique Landscape*, now in Edinburgh, and *Bathers at Tahiti*, now in Birmingham. We are immensely grateful to the National Galleries of Scotland and the Barber Institute of Fine Arts for having allowed these works to be temporarily reunited with Courtauld's other works by Gauguin for this project.

Collecting Gauguin has been curated by Karen Serres, the Gallery's Schroder Foundation Curator of Paintings, who has researched and prepared an illuminating publication that presents a rich account of Courtauld's purchases in the context of early taste for Gauguin's work in Britain. I want to thank her for the exceptional commitment this demanded. It is also a pleasure to thank the Schroder Foundation for its continued support of her position. For help with archival research and catalogue information, Karen would like to thank Martin Bailey, Frances Fowle, Donald Prochera, Magali Rougeot and Robert Wenley. As ever, thanks are also due to Karin Kyburz for assistance with images. The Courtauld wishes to thank HM Government for the provision of indemnity for this project and the Department of Culture, Media and Sport, and Arts Council England for administering this indemnity.

Ernst Vegelin van Claerbergen
HEAD OF THE COURTAULD GALLERY

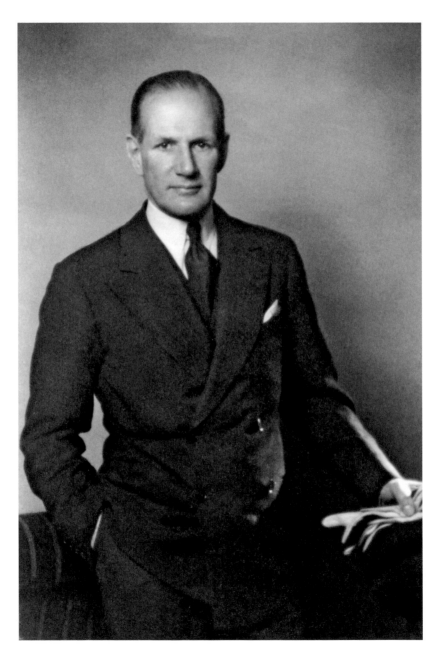

1 Samuel Courtauld (1876–1947)

INTRODUCTION

In March 1929, the artist, critic and art historian Roger Fry wrote to Samuel Courtauld from Paris detailing his recent visit to the gallery of the art dealer Paul Rosenberg. He described a number of beautiful works by Paul Cézanne, a painter Fry and Courtauld admired and actively championed in Britain.[1] However, what struck Fry most during his visit was a large painting by Paul Gauguin, representing two seated women watching over a sleeping infant in a hut. He reported that the work, then called *La Case*, "was an absolute revelation to me of what Gauguin was capable of. Gauguin has not maintained with me the prestige he had in the early days but this seemed to me to show that after all there was something very big about him". The following week, he repeated his praise of the "Gauguin which I feel confident is his masterpiece".[2]

The purchase of Gauguin's *La Case*, now known as *Te Rerioa* and one of the jewels of The Courtauld Gallery (cat. 4), by Samuel Courtauld marked the culmination of his almost decade-long interest in the artist. Courtauld (fig. 1), a distinguished philanthropist and chairman of the eponymous international textile company, had been acquiring Impressionist and Post-Impressionist works of art since the beginning of the 1920s. While he was not the earliest collector of Gauguin in Britain, he was one of only two individuals to assemble a major group of works by him. By the end of the decade, he held the most important Gauguin collection in this country, encompassing five paintings, ten woodcuts and one piece of sculpture.

Fry's "revelation" about the importance of Gauguin, so enthusiastically expressed in his 1929 letter to Courtauld, is somewhat startling in view of the pivotal role he had played in introducing Gauguin's art to the British public. Two decades earlier, Fry had organised the ground-breaking exhibition *Manet and the Post-Impressionists*, held at the Grafton Galleries in London from November 1910 to January 1911.[3] A member of the avant-garde, Fry championed modern French art as an example to be emulated by young British artists. Gauguin was the best represented artist in the show: out of around two hundred and fifty works on view, at least forty-two were by Gauguin, while the other members of the Post-Impressionist trinity, Vincent van Gogh and Paul Cézanne, had around thirty and twenty-one respectively.[4] Fry had travelled to Paris a few months earlier to solicit loans from the leading dealers of modern art, including Ambroise Vollard and Eugène Druet. Sensing an opportunity to bolster these artists' reputation abroad and enter a burgeoning market, the French dealers had responded generously.

Gauguin also featured on the poster to the Grafton Galleries exhibition (cat. 19). The London correspondent for *American Art News* reported that "a most remarkable painting by a great French painter is to be seen in London's tube lifts and elsewhere this

week. It is a picture of a Tahiti native woman, and in the corner of the canvas there is a grim grinning little black imp which stamps the work at once as from the brush of Gauguin."[5] While the poster's black and white illustration could not prepare visitors for the vibrancy of Gauguin's colours, its subject matter must have caused quite a stir in the streets and "tube lifts" of London. This painting held special appeal for Fry as it embodied both literally and metaphorically the notion of primitivism in art that he was so keen to promote. The preface to the exhibition catalogue, written by the literary journalist Desmond McCarthy from Fry's notes, emphasises the honesty and power of Gauguin's abstraction of form and use of colour: "in his Tahitian pictures by extreme simplification he endeavoured to bring back into modern painting the significance of gesture and movement characteristic of primitive art".[6] Gauguin largely escaped the wrath and derision the press unleashed on all the other exhibited artists owing to his striking use of colour and exotic motifs, which rendered his work more accessible and 'decorative'. The catalogue explains that Gauguin "deliberately chose ... to become a decorative painter, believing that this was the most direct way of impressing upon the imagination the emotion he wished to perpetuate".[7]

Visitors to the exhibition, however, focused less on Gauguin's radical divergence from Impressionism and his stylistic primitivism than on his literal return to a primitive state. His departure from Paris, abandoning his wife and children in search of a society untainted by Western civilisation – first in the Caribbean, followed a few years later by Tahiti and the Marquesas Islands in the South Pacific – was deliciously scandalous, the object of curiosity and fascination. It also presented Gauguin as an

uncompromising genius and conferred on to him a near mythical status. The absorbing details of his biography tainted the way his work was perceived. Whereas some saw a "primitive grandeur", most of the critical responses demonstrate persistent racism when discussing his subject matter: one critic reported, "in the large gallery the eye meets Gauguin's primitive, almost barbaric, studies of Tahitian women – bizarre, morbid, and horrible".[8]

The 1910 exhibition is widely recognised as a turning point for Gauguin's reputation in Britain. Gauguin's work had crossed the Channel twice before, to little critical notice. In 1908, one of his paintings was presented at the *Eighth Exhibition of the International Society of Painters, Sculptors and Gravers* at the New Gallery in London[9] and the *Exhibition of the Works of Modern French Artists*, held at the Public Art Galleries in Brighton over the summer of 1910, featured three paintings.[10] Despite the reviewers' mixed reactions, the Grafton Galleries exhibition provided Londoners with unprecedented exposure to his work and acted as a catalyst for the gradual recognition in Britain of Gauguin's importance. It is a measure of its success that many lamented the fact that owning a Post-Impressionist painting was out of reach for most visitors. As Clive Bell noted, the "art-loving public" who flocked to the Grafton Galleries was chiefly "composed of men and women of moderate means, and already in 1910 the works of Cézanne, Gauguin and Van Gogh were beyond those means".[11] Ambroise Vollard, who owned one of the largest inventories of Gauguin's works, had been selling them to eager collectors from Germany and Russia for a decade and his legendary business acumen ensured that prices rose steadily.[12] Fry himself only purchased one modest

work by Gauguin from the exhibition, an unfinished oil sketch of *Tahitians* (*c.* 1891) that he donated to the National Gallery in 1917 through the Contemporary Art Society. It was the first work by Gauguin to enter a British public collection.[13]

Collecting Gauguin in Britain in the 1910s therefore implied financial means and Parisian contacts. The Grafton Galleries exhibition converted at least one such individual into one of the earliest and most influential supporters of the artist in this country. Michael Sadler (1861–1943) was a leading writer on educational theory, which he taught at the University of Manchester before becoming vice-chancellor of the University of Leeds in 1911. A few months after the close of the Grafton Galleries loan show, Sadler purchased a pastel of a Tahitian girl and three key oil paintings by Gauguin: two of these paintings – *Manaò tupapaú* (The Spirit of the Dead are watching) (fig. 2) and *Christ in the Garden* (Norton Museum of Art, West Palm Beach, FL) – he had admired in person in London, while the third, *The Vision after the Sermon* (National Galleries of Scotland, Edinburgh), was purchased after a visit to Vollard's gallery in Paris.[14] These works formed the core of an exhibition on *Cézanne and Gauguin* at the Stafford Gallery in London that November.[15] Sadler continued to acquire through the 1910s. In 1912, for example, he purchased *Poèmes barbares* (1896, Fogg Art Museum, Cambridge, MA), the painting that Fry had featured on the Grafton Galleries poster. The greatest concentration of works by Gauguin at the time could therefore be found not in London but in Sadler's home in Leeds, where he showcased his collection by hosting regular gatherings.[16] This spectacular group of works by Gauguin was dispersed in the mid-1920s, owing to

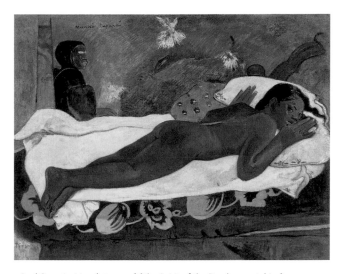

2 Paul Gauguin, *Manaò tupapaú* (The Spirit of the Dead are watching), 1892, oil on canvas, Albright Knox Art Gallery, Buffalo, NY

financial constraints and Sadler's changing interests, just as Samuel Courtauld was starting his collection. Of all the Gauguins in Sadler's pioneering collection, only *The Vision after the Sermon* remains in Britain, thanks to its bold purchase by the National Galleries of Scotland in 1925.[17]

In the first three years of his presence in Britain, Gauguin thus featured in exhibitions put together by four types of organisations: the artists' society (International Society of Painters in 1908), the public gallery (Brighton in 1910), the exhibition society (Grafton Galleries in 1910–11) and the dealer (Stafford Gallery in 1911). However, these displays were all ephemeral and had clear commercial interests.[18] The introduction of Gauguin's work into public collections was to prove a more protracted process.[19] His work made a discreet entrance with Fry's gift to the National Gallery in 1917 and the acquisition of a *Vase of Flowers* (1896, National Gallery, London) the following year

from Edgar Degas's estate sale in Paris.[20] While minutes of the National Gallery's Board of Trustees meetings reveal that, of all the Post-Impressionist artists, Gauguin was deemed the most desirable, the trustees turned down the opportunity to purchase *Nevermore* (cat. 3) twice, in 1919 and 1921. They wondered if "there were more important examples of Gauguin's work available for purchase".[21]

The National Gallery Board's equivocation about works created three decades earlier and by then widely considered mainstream on the Continent undoubtedly played a role in Samuel Courtauld's decision in 1923 to donate £50,000 to the nation for the purchase of modern French art. The Courtauld Fund was administered by a separate board of trustees, on which sat Michael Sadler. Despite Courtauld's and Sadler's enthusiasm for the artist, no works by Gauguin had been purchased when the grant ran out four years later. Courtauld was adamant that the Fund be used to include a variety of artists and it is possible that, given the persistent high prices, it was felt that purchasing a masterwork by Gauguin would rapidly deplete it and thus come at the expense of other acquisitions. As late as 1927, the director of the National Gallery, Sir Charles Holmes, remarked that "it is the fashion of the moment to speak of Gauguin as if he were a mere decorator; a maker of agreeable colour patterns without much substance or significance. Certainly none of the paintings by him which we possess at present could be used as a quite convincing argument to the contrary. But the best of his works in *private possession* [my emphasis] do very much more than combine formidable colour with striking and audacious design. They have real substance".[22]

Samuel Courtauld's own decisive encounter with Post-Impressionism has often been traced back to his visit to the loan exhibition *The French School of the Last Hundred Years* at the Burlington Fine Arts Club in 1922.[23] Fry was on the organisation committee and, as he had in 1910, played a key role in selecting the loans. Six paintings by *Cézanne* were on display, while Gauguin was represented solely by Sadler's *Manaò tupapaú* (fig. 2).[24] This distribution reflected Fry's own development and contemporary critical reception of Gauguin. After his central role in the 'Art Quake of 1910',[25] Gauguin did not feature in the Second Post-Impressionist exhibition of 1912, which focused on Cézanne and contemporary artists. While critics progressively turned away from Gauguin, a reverse trend could be found amongst collectors, who paid increasingly higher prices for masterpieces by the artist. The 1920s saw a spike in the acquisition of his work, with Courtauld playing a pivotal role.[26]

A few months after his visit to the Burlington Fine Arts Club, Courtauld purchased two paintings by Gauguin from the Parisian dealer Jos Hessel for £1,500, his first acquisition of works by a Post-Impressionist artist.[27] In one stroke, he acquired an example from each of Gauguin's two key periods – his years in Brittany with *Les Meules* (1889; cat. 2 and fig. 3), and a Tahitian composition, *Bathers at Tahiti* (1897; cat. 5). From the start, Gauguin seems to have appealed strongly and instinctually to Courtauld: a friend reported that "the sensuous colours of the above mentioned painter [Gauguin] steal a march on Sam".[28]

The landmark event in the reception of Gauguin in Britain took place in July 1924 at the Leicester Galleries, a commercial gallery located on Leicester Square, London.[29] It hosted the first monographic

exhibition on the artist in the country, catering to affluent collectors and the rising interest in Post-Impressionism. Solo exhibitions, especially on a deceased artist, remained a relatively new phenomenon, making all the more impressive the gathering of seventy works by Gauguin at the Leicester Galleries. This exhibition had been preceded by one on Van Gogh the previous December, the first of its kind for a Post-Impressionist artist in Britain. Cézanne would be next, in June 1925. On the walls of the Leicester Galleries hung works sourced from British private collections alongside works for sale. Sadler was exceptionally supportive, lending his five paintings and three works on paper, while Courtauld's two purchases from Hessel were also included in the show. Unusually, most of the works for sale were not loans from foreign dealers but seem to have belonged to the Leicester Galleries, including several purchased directly from Gauguin's heirs. Most important for Courtauld was the fact that out of the sixteen works by Gauguin (including prints) that would eventually form part of his superlative collection, twelve featured in the exhibition.

The first of Courtauld's purchases from the display was a set of ten woodcuts (cat. 7–16). Their appeal resided not only in Gauguin's innovation as a printmaker who experimented with different types of supports, cutting tools and ink colours, but also in their imagery, representing the religious lore of Tahiti, which recurs throughout Gauguin's oeuvre. In contrast, Courtauld's second purchase from the 1924 commercial exhibition, the portrait head in marble of Gauguin's Danish wife, Mette (cat. 6), was a radical departure. What could have motivated the acquisition of this striking but relatively academic portrait quite

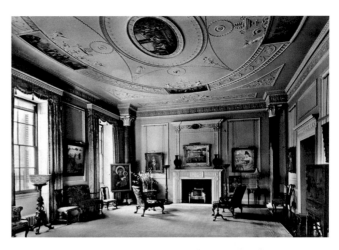

3 Interior of Home House, c. 1930, with *Les Meules* on the far left

foreign to anything else in Gauguin's oeuvre? In this case, the appeal of the sitter, her gentle demeanour and forlorn gaze may have been the primary attraction.

The final work purchased among those exhibited at the Leicester Galleries was one of Gauguin's most striking Tahitian canvases, *Nevermore* (cat. 3). This work was on loan from the collection of Herbert Coleman, a shipping merchant based in Manchester with a noted interest in modern French art who had purchased the painting after its rejection by the National Gallery. Courtauld was already considering acquiring the painting in July 1924 but the precise date and circumstances of its sale remain unclear; it is likely that *Nevermore* entered Courtauld's collection a few years later, in early 1927.[30]

Courtauld closed the decade by making two final purchases. By acquiring *Paysage Exotique* (now known as *Martinique Landscape*: cat. 1) in 1928, Courtauld added a work from Gauguin's early sojourn in Martinique, a French territory in the Caribbean,

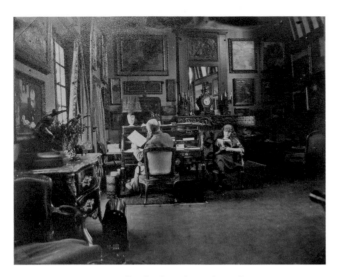

4 Gustave Fayet and his daughter Aline in the study at the Château d'Igny, *c.* 1912, with *Te Rerioa* above his desk

his first artistic journey abroad away from Western civilisation and in search of 'unspoilt' cultures. His last purchase, *Te Rerioa*, was the work that Fry saw in Paris in 1929 and so emphatically believed was "the masterpiece of Gauguin". Contrary to what is often assumed, Fry did not alert Courtauld to the painting's existence. Courtauld regularly visited commercial galleries in London and on the Continent and he had seen the work at Paul Rosenberg's Parisian gallery in December 1928, three months before Fry's own visit at Courtauld's request. Executed as part of a series of ambitious large canvases at a pivotal time of Gauguin's career, *Te Rerioa* also had a compelling biographical component: it was believed at the time to represent the interior of Gauguin's own dwelling in Tahiti, decorated with carved low-reliefs similar to the ones described in his correspondence. The painting's first owner, Gustave Fayet, installed it above his desk in

his study alongside numerous wood carvings by the artist, including several made specifically for him (fig. 4). Over the years, Fayet owned more than a hundred works by Gauguin but *Te Rerioa* obviously had a special status.

Fry worried that the price of the painting would be "colossal" and wondered if it would be "worth your while your considering selling your Nevermore and getting this [Te Rerioa]".[31] It is highly unlikely that Courtauld would have considered parting with *Nevermore,* although, as we will see, he did sell two works by Gauguin that year. *Te Rerioa* was indeed valued at a colossal price, £16,000, and Rosenberg was sure that he "could get a higher price in America".[32] In the end, Courtauld secured the work for £13,600 and hung it prominently in his London residence (fig. 5). Such a high valuation was on par with the steadily rising market for Gauguin's work since the beginning of the century. Up until 1930, his works regularly fetched much higher prices than any of his contemporaries or the Impressionists.[33]

As interesting as the works Courtauld purchased are the ones he turned down. In addition to *Te Rerioa*, Courtauld saw two other works by Gauguin at Rosenberg's in the winter of 1928. One, "Jeunes Filles", has not been securely identified but must have been important, considering its high valuation of £14,000.[34] The other work, "Soleils", is very probably *Nature morte à l'Espérance* (now in a private collection), a still life executed in 1901 and representing large sunflowers on a table. Even this modest work was valued at £5,000. That same year, Courtauld was presented with the opportunity to purchase Gauguin's monumental canvas, *D'où venons nous / Que sommes nous / Où allons nous* (Where do we come from / What are we / Where

are we going; 1897–98, Museum of Fine Arts, Boston).
Its owner, the Norwegian amateur Jorgen Breder
Stang, had decided to sell part of his Impressionist
and Post-Impressionist collection and approached
Courtauld through the Berlin-based dealer Alfred
Gold.[35] Gauguin considered *D'où venons nous* to be his
spiritual and artistic testament. It is surprising to think
that Courtauld, who was so mindful about gathering
prominent examples of Post-Impressionist art, did not
seize this opportunity. But, in 1928, the Courtauld Fund
had been spent and Samuel Courtauld was purchasing
solely for himself. In addition to financial concerns
over what was must have been an astronomical
price tag, the consideration of living with the work
every day was at the forefront of Courtauld's mind.
His emotional response to a specific work of art was
always the deciding factor in all his purchases, as well
as the spiritual enrichment one gained by repeated
viewing. In this case, it was Stang's great Cézanne *The
Card Players* rather than his epic Gauguin that held the
greatest appeal for Courtauld.

When Fry recommended that Courtauld sell
Nevermore to purchase *Te Rerioa*, he may have had
in mind a transaction taking place at the very same
moment: in order to purchase *The Card Players*,
Courtauld offered Gold, the dealer acting on Stang's
behalf, an exchange "with some ... Cézannes or a
Tahiti-Gauguin".[36] The exchange fell through as
Stang would only accept cash but Gold agreed
to sell Gauguin's *Bathers at Tahiti* for Courtauld
independently and the painting left London for
Berlin in August 1929. This culling fits into a more
general trend of Courtauld's later collecting practice:
that same year, Courtauld sold one of the Cézannes
he had offered to Gold, *Portrait of Madame Cézanne*

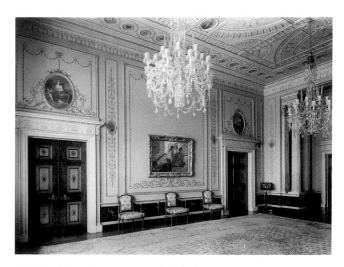

5 Interior of Home House, c. 1930, with *Te Rerioa*

(Philadelphia Museum of Art), to Paul Rosenberg
and exchanged a *Dancer* by Matisse (Hermitage,
Saint-Petersburg) as part payment for Renoir's *The
Skiff* (National Gallery, London). There is no reason
to suppose that he was anticipating the financial
difficulties that shook the world in the autumn of
1929. Was he simply reassessing his collection? It is
striking that, out of the six works Courtauld ever sold,
two were by Gauguin. In addition to *Bathers at Tahiti*,
which may have been "made superfluous"[37] by the
purchase of *Te Rerioa*, *Martinique Landscape*, which
Courtauld had purchased only in 1928, also left his
collection at the turn of the decade. The circumstances
of its sale, however, are unknown.[38]

The great retrospective of *French Art 1200–1900*
organised by the Royal Academy in 1932 marked the
official recognition of the artists championed by
Samuel Courtauld and Roger Fry, both members of
the executive committee. No longer isolated, works

by Impressionist and Post-Impressionist painters hung alongside those of the greatest French artists of previous centuries. Courtauld lent fifteen paintings and six drawings to the ambitious exhibition and later that year presented part of his collection to the Home House Society (now the Samuel Courtauld Trust) as a permanent memorial to his wife Elizabeth, who had died the year before. The paintings were on view at Home House in Portman Square, Courtauld's former home, which now housed the newly established Courtauld Institute of Art, the first public institution of higher education in the United Kingdom dedicated to the study of the history of art. Gauguin's paintings and sculpture were all included in the gift. Samuel Courtauld kept the prints, which hung in his home, until his death in 1947 when they joined the rest of the collection.

1 See London 2008.
2 The Courtauld Gallery archives, letters from Roger Fry to Samuel Courtauld, 22 and 28 March 1929; reproduced on pp. 58–59.
3 Much has been written about this pioneering exhibition and its reception: Douglas Cooper, 'Introduction', in Cooper 1954, pp. 9–78 (52–54); Bullen 1988; London 1997; London 1999–2000; Bullen 2003; special issue of *The Burlington Magazine,* vol. CLII, no. 1293, December 2010 and Amy Dickson 'Gauguin: a very British reception', in London and Washington 2010–2011, pp. 64–69.
4 See Gruetzner Robins 2010. These numbers must however be nuanced and have more to do with the availability of these artists' works at short notice than with Fry's personal hierarchy.
5 'London Letter' 1910.
6 Desmond McCarthy, 'The Post-Impressionists', in London 1910–1911, pp. 7–13 (11).
7 Ibid.
8 Quoted by Bullen 2003, pp. 105 and 111.
9 London 1908, no. 410: the work was *Haere Pape*, now at the Barnes Foundation, in Merion and Philadelphia.
10 Nos. 165: *Les Boeufs* (*The Oxen*) lent by the dealer Ambroise Vollard; 179: *Bretagne* (*In Brittany*) and 180: *Fruits de Tahiti*, both lent by Alphonse Kann. The exhibition ran from June to August 1910 and was organised by Robert Dell, one of the founders of *The Burlington Magazine* and by then a Paris-based art critic. It was to be the first of a series of displays showcasing contemporary foreign art.
11 Bell 1956, p. 82.
12 For Gauguin's posthumous reputation in France and Germany, see Kropmanns 1999 and Cahn 2003. Vollard was the first to organise a monographic exhibition on the artist following his death in 1903. A more comprehensive retrospective took place at the Salon d'Automne in Paris three years later.
13 In 1917, the remit of the National Gallery at Millbank, in charge of British art, was expanded to include modern and contemporary foreign art. It was renamed the Tate Gallery in 1932.
14 Gauguin prices seem to have been a challenge even for Sadler from the very beginning: his son recounts that, in 1911, he "was jotting large-scale calculations in one of his tiny black notebooks as to the lengths permissible in order to secure a front-rank Cézanne and at least two Gauguins": Sadleir 1947, p. 232.
15 The gallery was run by John Neville, Sadler's close adviser. The exhibition was commemorated in Spencer Gore's famous painting, *Gauguins and the Connoisseurs* (private collection), in which Sadler's friends are represented admiring his paintings on display.
16 The young Henry Moore was particularly inspired: "in those days [the late 1910s] the museum in Leeds had no work later than the Victorian period. [...] But Sir Michael Sadler had a Gauguin, a wonderful Gauguin, and other things. It was the Gauguin and a few ones like that which impressed me most", quoted in Donald Carroll, *The Donald Carroll Interviews*, London, 1973, p. 35.
17 Frances Fowle, 'Following the Vision: from Brittany to Edinburgh', in Edinburgh 2005, pp. 101–110.
18 Even the Brighton Public Art Galleries catalogue clearly listed the price of each work, alongside its title and the lender's name.
19 The process was not necessarily easier in France. The first work by Gauguin in a French national collection entered through a bequest in 1910 (*Still-life with Oranges*, Musée d'Orsay). The first purchase was made in 1913 by the Musée des Beaux-Arts in Lyon (*Nave Nave*

Mahana). As late as 1925, there was great resistance within the Louvre to Monfreid's bequest of Gauguin's *Noa Noa* album and the proposed purchase of *The White Horse* in 1927.

20 New York 1997, p. 230.

21 London 1994, pp. 12 and 31, n. 29; Korn 2001, p. 129.

22 Holmes 1927, pp. 136–37.

23 Anthony Blunt, 'Samuel Courtauld as Collector and Benefactor', in Cooper 1954, pp. 1–8 (3) implies that Courtauld attended the 1910 exhibition at the Grafton Galleries but that his negative response to Fauvism coloured his view of the show.

24 London 1922, no. 21.

25 Desmond MacCarthy, 'The Art Quake of 1910', *Listener*, 1 February 1945, p. 129.

26 In the 1920s, the number of paintings by Gauguin in UK collections more than doubled, going from a dozen in the early part of the decade to almost thirty in 1929.

27 Indeed, they could be seen as Samuel Courtauld's very first acquisitions of modern art, as the receipt for the first two purchases—*Saint Paul* by Jean Marchand and *Femme se Chaussant* by Auguste Renoir—is clearly addressed to 'Mrs Courtauld'. Hessel probably purchased *Bathers at Tahiti* from Edgar Degas's estate in 1918 for 14,010 French francs and paid Gabriel Frizeau, one of Gauguin's earliest collectors, 25,000 French francs for *Les Meules* and another, unidentified work in 1921. Even with allowances made for the exchange rate and inflation, this means that Hessel more than quadrupled his investment.

28 Letter from Lydia Lopokova to John Maynard Keynes, 1 November 1923, quoted in Hill and Keynes ed. 1989, p. 119.

29 It included forty-one works on paper, twenty-five oil paintings and three pieces of sculpture.

30 Minutes of the Tate Gallery's Board of Trustees, 23 February 1927, quoted by Korn 2001, p. 129. Courtauld's interest in *Nevermore* is clear in a letter he received from Michael Sadler on 29 July 1924: "If you have in mind to give Nevermore, it would be some other Gauguin than L'Esprit Veille [*Manaò tupapaú*] that (if my family don't object) I should like to think of as promise to the Nation. If you don't think of giving Nevermore, perhaps L'Esprit Veille would be acceptable": quoted in Korn 2001, p. 158.

31 The Courtauld Gallery archives, letter from Roger Fry to Samuel Courtauld, 22 March 1929, p. 2.

32 The Courtauld Gallery archives, letter from Paul Rosenberg to Samuel Courtauld, 8 January 1929, p. 2.

33 The end of the decade marked a slight shift however as Cézanne's works began to outpace Gauguin's. Courtauld paid £14,250 for Cézanne's *Montagne Sainte-Victoire* and £12,500 for *The Card Players*; see London 2008, p. 16. For the earlier generations of artists, only Manet's *Bar at the Folies-Bergère* and *La Loge* by Renoir had been more expensive. Courtauld paid $110,000 (around £22,600) for each work: see London 1994, p. 222.

34 'Jeunes Filles' may refer to *Mata Mua* (Carmen Thyssen-Bornemisza Collection, Madrid), owned by Rosenberg at the time. However, it is hard to be sure as Rosenberg accessioned more than two dozen works by Gauguin in 1928 alone, in addition to works he held in partnership with other dealers. I am very grateful to Dr Donald Prochera at the Paul Rosenberg archives for this information.

35 The Courtauld Gallery archives, letter from Alfred Gold to Samuel Courtauld, 11 September 1928: '1) The large <u>Gauguin</u>: Tahiti / ca 1,80m high, 3,80 large'. The National Gallery had been offered the painting in 1917 but was not able to raise sufficient funds. Lord Duveen had given £2,000 towards the purchase and, when the acquisition fell through, he donated a related work by Gauguin, *Faa Iheihe*, in 1919.

36 The Courtauld Gallery archives, letter from Alfred Gold to Samuel Courtauld, 17 March 1929. See also London 2008, p. 16. While Courtauld was quite clear about which works he was willing to part with, Gold believed he could have his pick of the collection. In April 1929, he wrote to one of his clients, the Swiss collector Oskar Reinhart, that "from the collection of Mr Samuel Courtauld in London, I can now purchase some important paintings … including the famous 'Never More'." I want to thank Martin Bailey for bringing this letter to my attention. The offer undoubtedly stemmed more from Gold's eagerness than any firm discussions with Courtauld. It is unlikely that the latter would have considered selling *Nevermore*, given his continued commitment to promoting the best examples of Post-Impressionism in Britain and the fact that only two years earlier, he had reportedly received "a reduction of £525 in the price [for *Nevermore*] in view of Mr Courtauld's undertaking that the picture would eventually come to the nation": National Gallery Board minutes, 23 February 1927, quoted by Korn 2001, p. 129.

37 John House, 'Modern French Art for the Nation: Samuel Courtauld's Collection and Patronage in Context', in London 1994, pp. 9–33 (23).

38 In the catalogue of the 1932 exhibition of *French Art 1200–1900* at the Royal Academy, it is simply listed as on loan from the collection of Evan Charteris.

39 Morice 1919, p. 81.

40 Paris and Boston 1988–1989, p. 318.

CATALOGUE

1

Martinique Landscape, 1887

Oil on canvas, 115 x 88.5 cm
INSCRIPTIONS [bottom right] *P. Gauguin 1887*
National Galleries of Scotland, Edinburgh
NG 2220

PROVENANCE Ernest Chausson, Paris; his wife, Jeanne
Escudier; [Galerie Barbazanges, Paris] in 1923; [Alexander
Reid in partnership with Lefèvre Gallery, London] in
1923; Elizabeth Workman, London, from November 1923;
purchased through [Alex. Reid & Lefèvre, London] by
Samuel Courtauld, London, for £3,000 in October 1928;
sold by him before 1932; Evan Charteris, London, by
1932; purchased [through Wildenstein?] by Mr and Mrs
Alexander Maitland, Edinburgh in 1932; presented to the
National Galleries of Scotland by Sir Alexander Maitland in
memory of his wife Rosalind in 1960

SELECTED EXHIBITIONS *Première Exposition de l a Libre
Esthétique*, Brussels, 1894, no. 188; Salon d'Automne, Grand
Palais, Paris, 1906, no. 211; *Exposition d'œuvres des grands
maîtres du XIXᵉ*, Galerie Paul Rosenberg, Paris, May–June
1922, no. 42; *Exhibition of Post-Impressionist Masters:
Gauguin, Van Gogh, Toulouse-Lautrec, Representative
Pictures by Renoir*, Lefèvre Gallery, London, 1923, no. 23;
*Loans to the opening of the Modern Foreign Gallery, June
to October 1926*, National Gallery Millbank, London, not
numbered; London 1932, no. 521

SELECTED LITERATURE Wildenstein 1964, no. 232;
Wildenstein 2001, vol. 1, no. 248

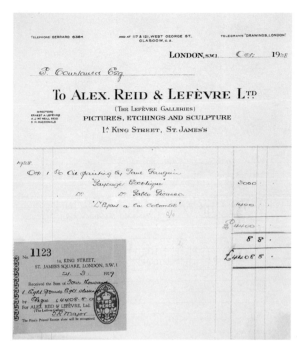

6 Receipt from the dealers Alex. Reid & Lefèvre for the
purchase of *Martinique Landscape* (then called *Paysage
Exotique*) in 1928

In April 1887, Gauguin set off for Panama with the
painter Charles Laval, in a first attempt to leave
European civilisation behind and find inspiration
in 'unspoilt' cultures. As with his later experiences
in Tahiti, reality never lived up to his ideals.
Gauguin worked, under punitive conditions,
on the construction of the Panama Canal for a
month before moving to the French island of
Martinique in the Caribbean. Nevertheless, this
voyage changed his life and proved to be a pivotal
experience in his artistic development. Years later,

7 Interior of Galerie Rosenberg, Paris in May 1922 showing *Martinique Landscape* in a white frame
Photo courtesy of The Paul Rosenberg Archives, New York

he wrote to his friend Charles Morice: "What I experienced in Martinique [...] is key. Only there did I truly feel like myself, and if you want to know who I am, you must look for me in what I brought back from there, more so than in my works from Brittany" (Morice 1919, p. 91).

During his five-month stay, Gauguin produced around fifteen canvases, including *Martinique Landscape*. This view of lush tropical vegetation is taken from a headland called 'Le Trou', high above the city of Saint-Pierre, then the capital of Martinique. In the distance rises Mount Pelée, the volcano whose eruption in 1902 completely destroyed the city. However, the landscape is carefully constructed: Gauguin has completely erased any hint of the bustling city below, exaggerated the size of the mountain in the background and lengthened the papaya tree on

the left to impossible heights in order to ground and unite the composition. Paths of ruddy earth dominate the foreground, while the surrounding rocks and vegetation are rendered as juxtaposed planes of colours. Particularly visible in this canvas is Gauguin's preference at that period for thin, short brushstrokes, conferring a hatched effect to the composition. This manner is reminiscent of Cézanne, of whom Gauguin owned half a dozen works. He used a similar technique in *Les Meules* (cat. 2), executed two years later in Brittany.

Gauguin's correspondence indicates that he had a strong preference for simple frames, ideally composed of plain mouldings painted white. In a letter to his brother Theo dated 10 November 1888, Vincent van Gogh asks "do you know that Gauguin is in a sense the inventor of the white frame?" A photograph taken in 1922 at Galerie Paul Rosenberg in Paris shows *Martinique Landscape* in such a frame (fig. 7). This frame has been lost as it was common practice at the time for collectors to change the frames of paintings they purchased in order to create a sense of harmony with their interior and the rest of their collection.

2

Les Meules (The Haystacks), 1889

Oil on canvas, 92 x 73.3 cm
INSCRIPTION [bottom right] *P Gauguin 89*
The Courtauld Gallery, London (Samuel Courtauld Trust)
P.1932.SC.162

PROVENANCE [Ambroise Vollard, Paris]; Gabriel Frizeau, Bordeaux; purchased from Frizeau by [Jos Hessel, Paris] in April 1921 for 25,000 French francs (with another, unidentified work); sold by Hessel to Samuel Courtauld in January 1923 for £1,500 (with *Bathers at Tahiti*); Courtauld Gift, 1932

SELECTED EXHIBITIONS London 1924, no. 61; London 1994, no. 19

SELECTED LITERATURE Wildenstein 1964, no. 352

Gauguin set off for his third extended stay in Brittany in April 1889. He had first visited in 1886, hoping to find in this remote western region of France a pure way of life untainted by modern civilisation. However, three years later, Gauguin found his usual base of Pont-Aven overrun by tourists and artists, and decided to move to the nearby hamlet of Le Pouldu.

Les Meules depicts the annual harvest and stacking of hay, left to dry in the fields and used for livestock fodder over the winter. Gauguin delighted in these timeless traditions but his romantic notion of rural life completely disregarded the great poverty and hardship endured by the local population. In a letter to Van Gogh written in December 1889, he writes, "Here in Brittany the peasants have a medieval look about them and don't appear to think for a moment that Paris exists and that we're in the year 1889 – quite the opposite of the south [Gauguin had spent two months living with Van Gogh in Arles the previous year]. Here

everything is harsh like the Breton language,
very closed-in (forever, it seems). The costumes
are also almost symbolic, influenced by the
superstitions of Catholicism. Look at the back,
[the] bodice a cross, the head wrapped in a black
kerchief like the nuns – in addition the figures
are almost Asiatic, yellow and triangular, severe."
The archaic costumes and angular features of the
Bretons described by Gauguin recur in *Les Meules*.

In addition, the painter created a claustro-
phobic atmosphere by flattening the perspective,
providing little spatial context and blocking the
horizon line with the towering stacks of golden
hay that occupy almost a third of the composition.
A strong black outline describes the schematic
forms and contrasts with the use of short, thin
brushstrokes to create a hatching effect that
captures the gleaming packed hay.

3

Nevermore, 1897

Oil on canvas, 60.5 x 116 cm
INSCRIPTIONS [upper left] *NEVERMORE / P. Gauguin 97 / O. TAÏTI*
The Courtauld Gallery, London (Samuel Courtauld Trust)
P.1932.SC.163

PROVENANCE Sent by the artist to Daniel de Monfreid, Paris; purchased in November 1898 by Frederick Delius, Paris and Gretz-sur-Loing for 500 French francs; purchased from Delius through [Goupil Gallery, London] by Herbert Coleman, Manchester in August 1922 for £3,000; purchased from Coleman by Samuel Courtauld before February 1927 (price unknown); Courtauld Gift, 1932

SELECTED EXHIBITIONS Salon d'Automne, Grand Palais, Paris, 1906, no. 216; *Internationale Kunstausstellung des Sonderbundes Westdeutscher Kunstfreunde und Künstler*, Ausstellungshalle, Cologne, May–September 1912, no. 168; *Loan Exhibition of Masterpieces of French Art of the Nineteenth Century*, Agnew's Gallery, Manchester, 1923, no. 17; London 1924, no. 52; *French Modern Art Exhibition*, Royal West of England Academy, Bristol, May–June 1930, no. 42; London 1932, no. 533; *Gauguin. Exposition du Centenaire*, Musée de l'Orangerie, Paris, 1949, no. 48; London 1994, no. 20; Washington, Chicago and Paris, 1988–89, no. 222; London and Washington, 2010–11, no. 118

SELECTED LITERATURE Wildenstein 1964, no. 558

Gauguin painted *Nevermore* in February 1897, during his second and final sojourn in Tahiti. Its elongated, frieze-like shape is unusual in Gauguin's oeuvre. It was probably cut down from a larger standard-size canvas like the one used for *Te Rerioa* (cat. 4). These canvases have coarse fibres and a loose weave, although the thick paint layer in *Nevermore* hides these characteristics. Indeed, Gauguin painted *Nevermore* on top of another, very different composition. Thanks to an infra-red scanner able to penetrate the paint surface and reveal the underlayers, it is possible to discern an elaborate tropical landscape, framed by palm trees on the left and a thick trunk on the right. The body of a horse is visible at the centre on the belly of the reclining figure and a chicken appears amidst vegetation below her forearm. In the background, an L-shaped hut with three small windows can be discerned to the left of a tall tree (these are visible behind the headboard). This setting recalls contemporary paintings like *No te aha oe riri* (1896, Art Institute of Chicago).

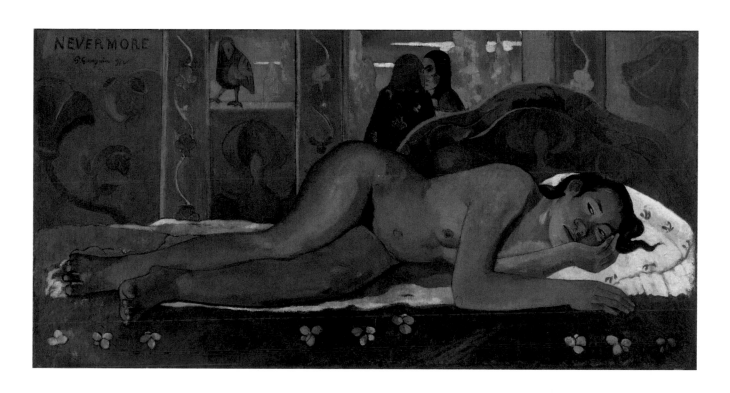

The female nude that has replaced this composition stems firmly from European tradition, from Titian's Venuses to Ingres's exotic courtesans and Manet's *Olympia*, of which Gauguin once made a copy. The setting, however, is not one of eroticism or lust but rather of disquiet, as the reclining figure is alert to her surroundings. Whether these two figures in the background are malevolent spirits or mere visitors is unclear; their status is left deliberately ambiguous. Gauguin considered this work one of his masterpieces and left specific instructions that it be included in a retrospective of his œuvre. Upon seeing the work in 1922, Michael Sadler, who was undoubtedly the British collector who had seen the greatest number of paintings by Gauguin at that time, described it as "superb. One of the two or three best Gauguins …. It is the Poe poem translated into Tahiti" (quoted by Korn 2001, vol. 1, p. 125).

Instead of his usual Tahitian title, Gauguin turned to another foreign name and chose to call the painting 'Nevermore', an allusion to Edgar Allan Poe's poem 'The Raven' (first published in 1845, translated into French in 1875). In his correspondence, however, Gauguin rejected any equation of the bird perched on the window sill with Poe's ominous raven.

The painting was sold a year after its execution to the British composer Frederick Delius, who had lived in Paris for a decade and met Gauguin a few years previously. Thrilled that the painting had been purchased by an artist and acquaintance, and perhaps thinking that the English title had especially appealed to Delius, Gauguin teased his friend Monfreid in a letter dated 12 January 1899: "Do you remember you rebuked me for having given a title to this painting: don't you think this title *Nevermore* is the reason for this purchase? Perhaps!" Financial constraints forced Delius to sell the work after the First World War and his wife Jelka made a copy to replace the original above Delius's piano.

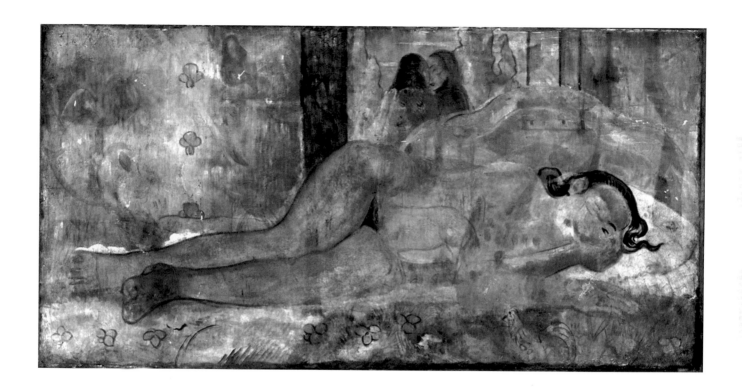

4

Te Rerioa (The Dream), 1897

Oil on canvas, 95.1 x 130.2 cm
INSCRIPTIONS [bottom centre] *TE RERIOA / P. Gauguin 97 / TAÏTI*
The Courtauld Gallery, London (Samuel Courtauld Trust)
P.1932.SC.164

PROVENANCE Sent by the artist to Daniel de Monfreid, Paris; on deposit with Monfreid's childhood friend Dr Calmel, Béziers, in 1900; purchased by Gustave Fayet, Béziers, in August 1903 for 3,300 French francs (with *Te Arii Vahine* and *Rupe Rupe*) and in his collection until his death in 1925; inherited by his son Léon; purchased by [Paul Rosenberg, Paris] in November 1928; purchased by Samuel Courtauld, London in July 1929 for £13,600; Courtauld Gift, 1932

SELECTED EXHIBITIONS Société des Beaux-Arts, Salle Berlioz, rue Solferino, Béziers, 1901, no. 51; *Ausstellung von Werken von Paul Gauguin*, Grossherzogliches Museum für Kunst und Kunstgewerbe am Karlsplatz, Weimar, 1905, no. 3; Salon d'Automne, Grand Palais, Paris, 1906, no. 4; London 1932, no. 520; *Gauguin. Exposition du Centenaire*, Musée de l'Orangerie, Paris, 1949, no. 49; Washington, Chicago and Paris 1988–89, no. 223; London 1994, no. 21; Paris and Boston 2003–04, no. 139; London and Washington, 2010–11, no. 120; *Gauguin Polynesia*, Ny Carlsberg Glypothek, Copenhagen and Seattle Art Museum, 2011–12, no. 282

SELECTED LITERATURE Wildenstein 1964, no. 557

Te Rerioa was painted in early March 1897, only a few weeks after *Nevermore*, and the two works travelled to France on the same ship. *Te Rerioa* was the last in a series of large canvases painted by Gauguin in the preceding months. The artist reported that he had produced this work in less than ten days, taking advantage of the delay in the ship's departure. However, the carefully constructed composition, its solemnity and balance, belie a completely spontaneous undertaking. Two imposing women sit on the floor of a hut. In the corner, an infant sleeps in an elaborately carved crib and a spotted cat rests nearby. Carved reliefs occupy the full length of the interior walls and depict an embracing couple, hybrid creatures and vegetation. Their symbolic meaning has been the subject of much speculation, but, like the women's relationship, Gauguin has left it deliberately ambiguous. Equally ambiguous is the connection between the hut and the colourful landscape in the background: is the landscape seen through a

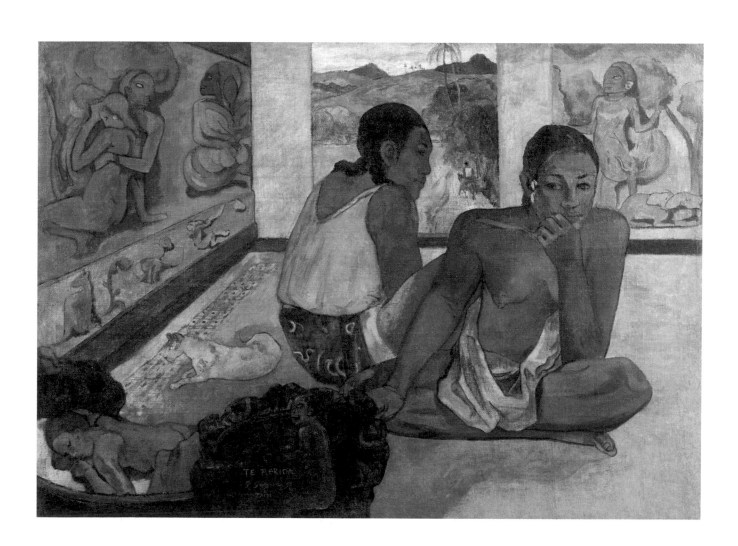

door or window, or is it itself another piece of décor? Finally, the strange perspective, sharply slanted floor and claustrophobic crop of the composition all add to the sense of unease. Explaining his choice of the title *Te Rereioa* (misspelt on the canvas) to his friend Monfreid, Gauguin wrote "Everything is dream in this canvas, whether it be the child, the mother, the horseman on the road, or the dream of the painter. All of this has nothing to do with painting, some will say. Who knows? Maybe not".

Gauguin started conferring Tahitian titles on his paintings from the early days of his sojourn in the South Pacific in 1891. He not only noted them in his ledger and explained them in his correspondence but he also inscribed them on the surface of the paintings themselves, yet another signifier for his European audience of his self-fashioned identity as an outsider. However, his Tahitian titles were never used by critics and collectors before the mid-twentieth century.

As a result, *Te Rerioa* was initially called 'Le Repos (The Rest)', 'La Case (The Hut)' and 'Intérieur de case à Tahiti (Interior of a Hut in Tahiti)'.

Part of the early appeal of this canvas lay in the fact that it was thought to represent the interior of Gauguin's own lodgings. While we know that he decorated the traditional habitation he moved into in 1898 with carved reliefs, nothing is known about earlier dwellings. The carvings on the wood crib differ from those on the wall and the two menacing, crouching figures at its feet have been linked to those on Maori presentation bowls. Gauguin stopped in New Zealand on his way to Tahiti and may have made sketches of such bowls. As always, his motif is not a straight transcription but an interpretation and amalgamation of patterns and shapes.

The coarse weave preferred by Gauguin for his canvases is readily apparent in *Te Rerioa* and shows through the thin paint layer, sometimes interfering with the legibility of the image.

5

Bathers at Tahiti, 1897

Oil on sacking, 73.3 x 91.8 cm
INSCRIPTIONS [bottom right] *P. Gauguin 97*
The Barber Institute of Fine Arts, University of Birmingham
49.9

PROVENANCE Sent by the artist to [Ambroise Vollard, Paris] in June 1898; possibly in the collection of Edgar Degas, Paris, and purchased by [Jos Hessel, Paris] at his sale in 1918 for 14,010 French francs (lot 47); purchased from Hessel by Samuel Courtauld, London in January 1923 for £1,500 (with *Les Meules*); placed on consignment with [Alfred Gold, Berlin] in 1929; Josef Stránský, Berlin and New York, until 1936; [Wildenstein, New York] in 1936; [Arthur Tooth & Sons, London] in 1937; Henry de Vere Clifton, Liverpool; [Arthur Tooth & Sons, London]; purchased from Tooth by the Henry Barber Trust in 1949 for £4,500 for display at the Barber Institute of Fine Arts.

SELECTED EXHIBITIONS Galerie Ambroise Vollard, Paris, November–December 1898; London 1924, no. 54; on loan to Worcester Art Museum, Worcester, MA, 1932–35; Paris and Boston 2003–04, nos. 143 (Paris) and 146 (Boston); *Gauguin Polynesia*, Ny Carlsberg Glypothek, Copenhagen and Seattle Art Museum, 2011–12, no. 293

SELECTED LITERATURE Wildenstein 1964, no. 564; New York, 1997, pp. 230–31

This painting belongs to a group of works executed at the same period as Gauguin was developing the monumental painted frieze he considered his spiritual and artistic manifesto, *D'où venons nous / Que sommes nous / Où allons nous* (Where do we come from / What are we / Where are we going; 1897–98, Museum of Fine Arts, Boston). In *Bathers at Tahiti*, Gauguin reused a motif from that large canvas, the young female bather holding on to a tree trunk in order to lower herself down into a small pool of water (or lift herself up after bathing). He must have been pleased with the effect as *Bathers at Tahiti* appears in the background of a painting executed shortly after, *Tahitian Woman* (fig. 8). However, the poses of the two bathers also derive from prints Gauguin owned after the eighteenth- and nineteenth-century masters Jean-Honoré Fragonard and Pierre-Paul Prud'hon, a testament to the artist's constant fusion and reuse of motifs.

The paint layer is characteristically applied very thinly, allowing the coarse weave of the canvas to

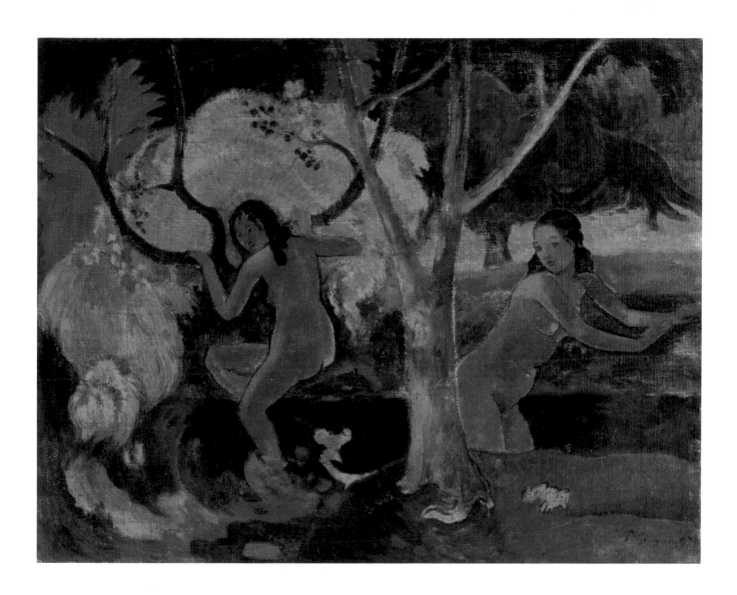

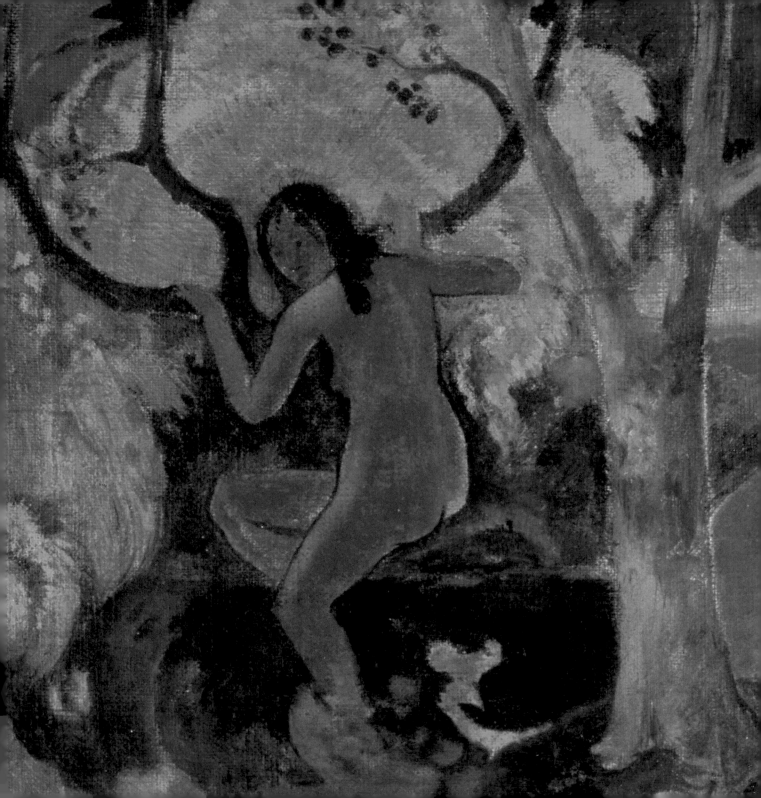

show through. Gauguin's letters reveal that he had a preference for a "thick and coarse" support. He deliberately left the irregular surface of the sacking visible to confer texture to his paintings. On a more symbolic level, the rough canvas was a way to express his search for an unadulterated way of life.

This painting most likely once belonged to the artist Edgar Degas, a steadfast supporter of Gauguin. The two artists met in 1879, the year Gauguin was first invited to participate in an Impressionist exhibition. Degas eventually owned two dozen paintings and works on paper by Gauguin, and continued to acquire works by his friend long after Gauguin's departure to Tahiti and his death in 1903.

8 Paul Gauguin, *Tahitian Woman*, 1898, oil on canvas, Ordrupgaard, Copenhagen

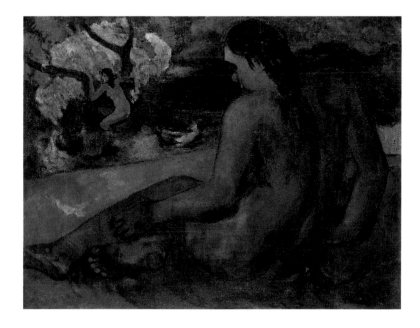

6

Portrait of Mette Gauguin, 1879–80

Marble, 34 x 26.5 x 18.5 cm (max)
INSCRIPTIONS [carved on the back of the collar] *P. Gauguin*
The Courtauld Gallery, London (Samuel Courtauld Trust)
S.1932.SC.73

PROVENANCE Mette Gauguin, Paris and Copenhagen;
her son, Pola Gauguin, Copenhagen; [Leicester Galleries,
London] by 1924; purchased from them by Samuel
Courtauld in March 1925 for £288.15; Courtauld Gift, 1932

SELECTED EXHIBITIONS *Fifth Impressionist Exhibition*,
Paris, 1880, no. 62; London 1924, no. B; London 1994, no.
67; *Gauguin and Impressionism*, Kimbell Art Museum, Fort
Worth and Ordrupgaard, Copenhagen, 2005–06, no. 7

SELECTED LITERATURE
Gray 1963, no. 1

This bust is the only signed work in marble
by Gauguin. It was first exhibited at the Fifth
Impressionist exhibition in 1880, where it was
judged competent but did not make a great
impact. The previous year, Gauguin had exhibited
another sculpture, the bust of his eldest son, Emil
(1874–1955; fig. 10), also in marble but unsigned.
Gauguin was still active as a stockbroker in those
years but was increasingly devoting his time to
painting and sculpture. For the latter, he worked

9 Paul and Mette Gauguin, 1885

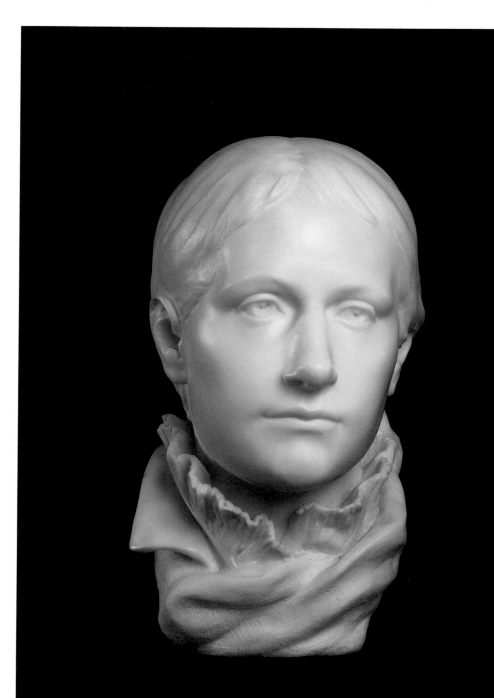

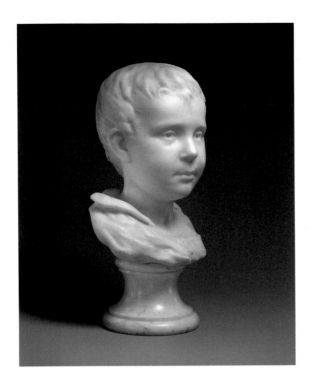

with malleable materials such as wax, clay and wood, the beginnings of a lifelong production of three-dimensional works. These two marble busts marked a rise in ambition, though the extent of Gauguin's direct involvement in their carving remains an open question. Marble is an expensive material and requires specialised technical skills to carve. Here, the sculptor's expertise is most visible in the use of drilling to create the thin space between Mette's neck and her raised ruffled collar, as well as in the contrast between the smooth finish of her skin and the rougher treatment of her hair. It is therefore likely that Gauguin collaborated with a trained sculptor, possibly his former landlord Jules-Ernest Bouillot, who began exhibiting at the Salon a few years later. The son of Gauguin's earliest supporter, the painter Camille Pissarro, recalled seeing a wax model of this bust at his father's house in Osny. This object may have served as a preparatory sketch for the marble and been given by Gauguin to Pissarro.

Paul Gauguin met the Danish-born Mette-Sophie Gad (1850–1920) in 1872. They were married the following year and had five children within the next decade. During that time, Gauguin used friends and family members as models in his art and this bust represents his wife at the age of twenty-nine. Strong-willed and sociable, Mette initially supported Gauguin in his artistic endeavours but their relationship slowly became strained after Gauguin lost his job. Around 1884, financial constraints forced Mette to move back to her native Denmark with her children and from then on the couple lived mostly apart.

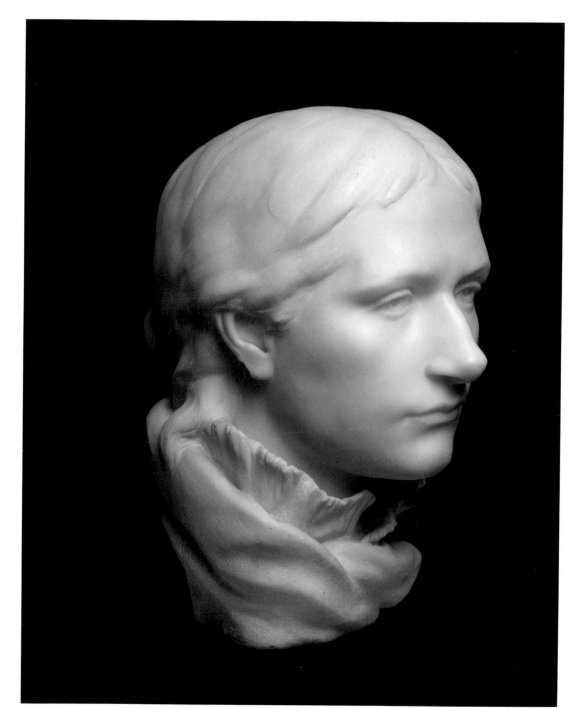

7–14

Eight woodblock prints from the Noa Noa series,
1893–94, printed 1921

From the portfolio *Paul Gauguin. 10 Træsnit* printed by Pola Gauguin and published
by Chr. Cato in Copenhagen in 1921 (edition of 100)
Wood engraving on China paper
All sheets inscribed in graphite in the same hand: [upper left] *No 28*; [lower left]
Paul Gauguin fait; [lower right] *Pola Gauguin imp.*
The Courtauld Gallery, London (Samuel Courtauld Trust)

7. **Noa Noa** (Fragrant, Fragrant)
36.5 x 20.6 cm (block); 42.9 x 27 cm (sheet)
G.1948.SC.182.2

8. **Auti Te Pape** (Women at the River)
20.5 x 35.5cm (block); 27 x 42.4 cm (sheet)
G.1948. SC.182.8

9. **Te Po** (Eternal Night)
20.4 x 35.9 cm (block); 26.7 x 42.2 cm (sheet)
G.1948.SC.182.1

10. **Nave Nave Fenua** (Delightful Land)
33.4 x 20.4 cm (block); 42.1 x 26.5 cm (sheet)
G.1948.SC.182.6

11. **Maruru** (Offerings of Gratitude)
20.5 x 35.6 cm (block); 26.8 x 42.6 cm (sheet)
G.1948.SC.182.4

12. **L'Univers est créé** (The Universe is created)
20.4 x 35.4 cm (block); 26.8 x 42.9 cm (sheet)
G.1948.SC.182.5

13. **Mahna No Varua Ino** (The Devil speaks)
20.2 x 35.4 cm (block); 26.8 x 42.7 cm (sheet)
G.1948.SC.182.7

14. **Manao tupapau** (The Spirits of the Dead are watching)
20.4 x 35.6 cm (block); 26.9 x 42.1 cm (sheet)
G.1948.SC.182.3

PROVENANCE Printed in Copenhagen in 1921 by Pola
Gauguin; [Leicester Galleries, London] by 1924; purchased
by Samuel Courtauld, London, in July 1924 for £47.5 (for the
portfolio); Courtauld Bequest, 1948

SELECTED EXHIBITIONS London 1924, nos 15, 19, 28–29,
31–34, 37, 41 (several versions present); London 1994, cat. 114

SELECTED LITERATURE Guérin 1927, nos 15–16, 23–24, 27–29,
32–35, 42–43, 89–90, 92, 94–96; Mongan, Kornfeld and
Joachim 1988, 13.E (b), 14.D (b), 16.D (b), 18.E (b), 19.E (b), 20.F
(b), 21.D (b), 22.E (b)

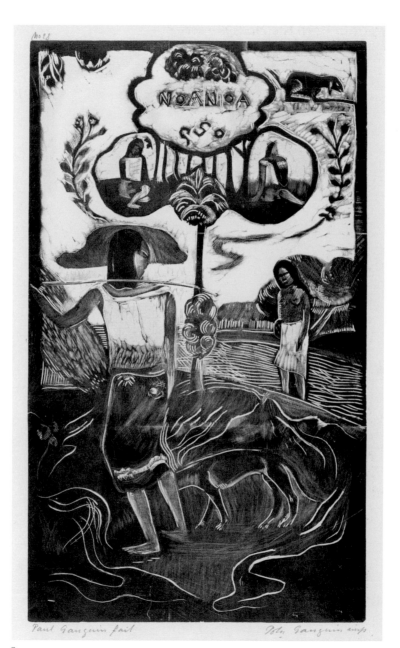

Paul Gauguin fait Pola Gauguin imp.

7

This set of prints comes from a portfolio printed by Gauguin's youngest son, Pola, almost two decades after his father's death. The portfolio contains eight of the ten prints from Gauguin's *Noa Noa* series (missing are *Te Atua* and *Te Faruru*) and two additional wood engravings (cat. 15 and 16). In 1919, Pola purchased the woodblocks engraved by his father from the Parisian dealer Eugène Druet and struggled for two years to issue prints that faithfully rendered their nuanced patterns, texture and marks.

Upon returning from his first Tahitian sojourn in 1893, Gauguin set about preparing a publication that would help European viewers understand his paintings. Texts were to be taken from his travel journal, entitled *Noa Noa* (Fragrant, Fragrant) (figs. 11 and 12), which combined romanticised personal recollections, local legends and anthropological descriptions. The publication would be complemented with poems by the writer Charles Morice and illustrated with ten prints, three vertical and seven horizontal. However, while they were perhaps originally conceived as chapter headings, the prints seem to have neither a direct relationship with the text nor a recognised order.

Gauguin worked exclusively on the woodblocks for these prints from December 1893 to April 1894. The publication he had envisaged never materialised but in December 1894 he exhibited the *Noa Noa* prints in his studio in Paris. Their imagery draws on sketches found in Gauguin's journal, motifs that are also found in his painted oeuvre. However, the prevalence of black, linked to the medium (examined below), sets many of the scenes at night and gives them a more menacing mood. While Gauguin aimed to provide his viewers with insights into the customs and

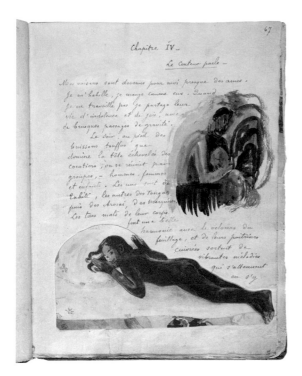

of the block is inked, the thin, recessed grooves remain free of ink and appear white on the paper, while the rest of the block prints black. Gauguin also employed more unconventional tools such as gouges traditionally used by sculptors, needles and razor blades. The latter were used to faintly scratch the wood and create subtle areas of light and shadow in order to model forms. In effect, Gauguin treated the woodblock like a low-relief sculpture and used a process that combined carving, drawing and printmaking in a truly innovative way.

spiritual life of Tahiti, the series is really a foray into the artist's own imagination: Charles Morice later summed up this sentiment perfectly, writing, "Here is the true Tahiti, that is to say faithfully imagined".

In addition to their powerful imagery, the *Noa Noa* prints are remarkable for their medium and technique. Gauguin used small boxwood blocks, which have a particularly tight grain and allow for fine cutting. He took advantage of this trait and incised the surface of the blocks with a variety of metal tools called gravers in a technique known as white-line wood engraving. When the surface

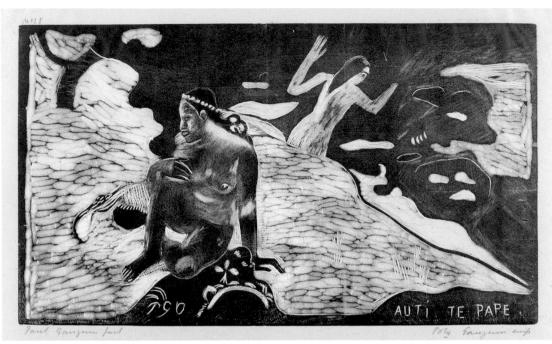

8

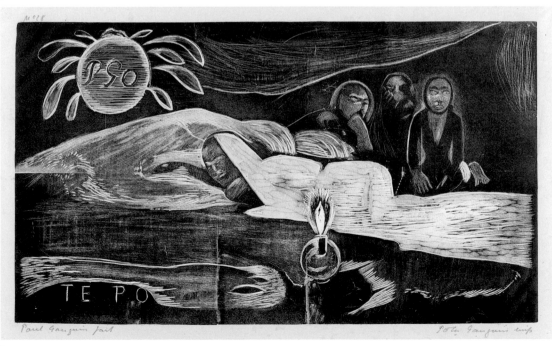

9

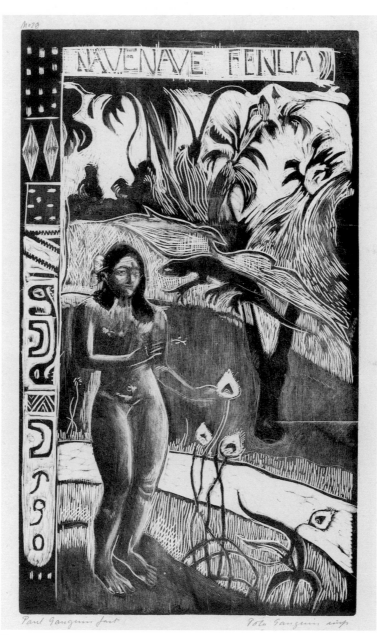

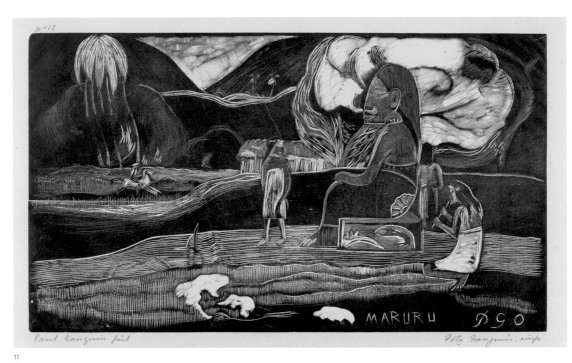

11

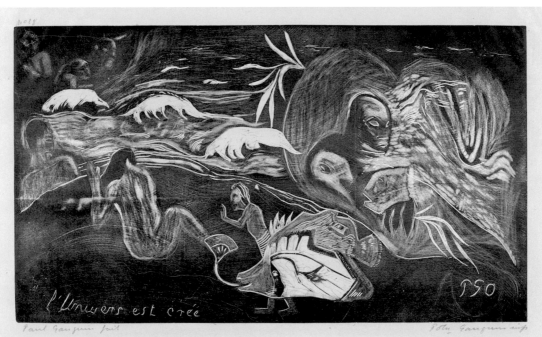

12

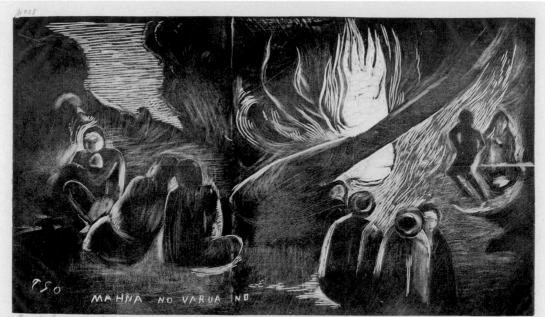

MAHNA NO VARUA INO

13

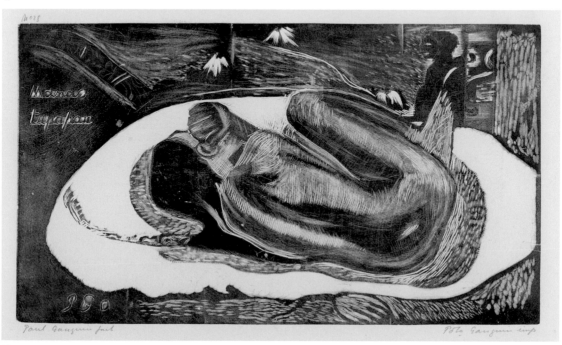

14

15

Mahna Atua (Day of the God), 1894–95

From the portfolio *Paul Gauguin. 10 Træsnit* printed by Pola Gauguin
and published by Chr. Cato in Copenhagen in 1921 (edition of 100)
Wood engraving on China paper, 18.2 x 20.3 cm (block); 26.6 x 42.7 cm (sheet)
The Courtauld Gallery, London (Samuel Courtauld Trust)
G.1948.SC.182.9

PROVENANCE see cat. 7–14

SELECTED EXHIBITIONS London 1924, no. 35 or 39

SELECTED LITERATURE Guérin 1927, no. 43; Mongan,
Kornfeld and Joachim 1988, 31.c (b)

Mahna Atua reprises, in reverse, elements from Gauguin's oil painting *Mahana No Atua* (1894, Art Institute of Chicago). Both the painting and the print were made in France, a year after Gauguin's return from Tahiti (he would go back to the South Pacific a year later and remain there for the rest of his life). Like the *Noa Noa* prints, they are therefore very much an imaginary representation of the South Seas. The balanced composition suggests a strongly symbolic arrangement but its meaning remains unclear: a young Tahitian woman dips her ankles in a pool of water, while two nude figures sleep on either side of her. The scene is flanked in the background by two pairs of women clad in pareos – large colourful cloths used as traditional dress. One pair carries provisions on their heads while the other performs a traditional Tahitian dance. The dominating figure at centre presiding over the scene has been identified as the moon goddess Hina but its appearance derives less from Polynesian religious imagery than from Indian and South-east Asian prototypes. Gauguin was familiar with Eastern art and architecture through his collection of photographs and books.

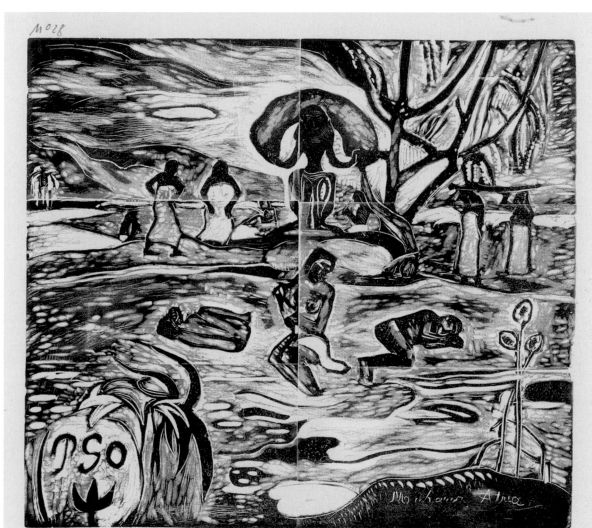

Paul Gauguin fecit Paul Gauguin imp.

16

Title page for Le Sourire, *November 1899*

From the portfolio *Paul Gauguin. 10 Træsnit* printed by Pola Gauguin and published
by Chr. Cato in Copenhagen in 1921 (edition of 100)
Wood engraving on China paper, 10.1 x 18.3 cm (block); 26.7 x 42.6 cm (sheet)
The Courtauld Gallery, London (Samuel Courtauld Trust)
G.1948.SC.182.10

PROVENANCE see cat. 7–14

SELECTED EXHIBITIONS London 1924, no. 16

SELECTED LITERATURE Guérin 1927, no. 76;
Mongan, Kornfeld and Joachim 1988, 58.D (b)

While this print, along with cat. 16, belongs to the portfolio printed in 1921 by Pola Gauguin (see cat. 7–14), it was initially created under very different circumstances. It served as the title page for the fourth issue of Gauguin's self-published satirical broadsheet *Le Sourire* (The Smile). Begun in August 1899 and printed monthly, it consisted of four to six pages of articles and illustrations, and had a run of about thirty. It aimed to denounce the pervasive corruption of the Church and government in Tahiti and quickly got Gauguin in trouble with the local authorities. Only nine issues were published and production stopped in April 1900.

Gauguin was both the writer and the illustrator, and created different wood engravings for each issue. The two blank cartouches in the lower part of the composition were meant to hold his signature and the print number. In a letter addressed to his friend Daniel de Monfreid in 1901, Gauguin wrote of his printmaking process, "it is precisely because this print goes back to the most primitive time of engraving ... that it is interesting ... I am sure that, in time, my woodblock prints, so different from anything else that is being done in printmaking, will be valuable".

The blocks, along with most of Gauguin's possessions, were sold after the artist's death by the Tahitian authorities to pay off his debts. Despite their poor condition, they were purchased by Victor Segalen, a young naval doctor with an interest in art and literature, and brought back to France.

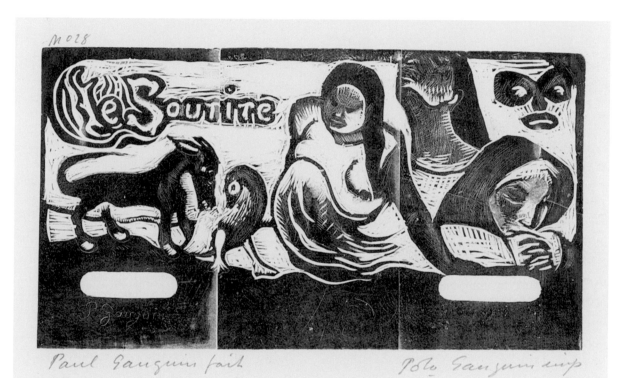

Paul Gauguin fait Pôlo Gauguin imp

17

Two studies of the head of a bearded man (recto)
and **Two Tahitian women viewed from the rear** (verso),
c. 1891–96

Red chalk (recto) and graphite and gouache (verso) on paper, 27.25 x 17.8 cm
INSCRIPTIONS [upper left, recto, in graphite] *43*; [lower right, recto, stamped in blue ink] *P.G.*
The Courtauld Gallery, London (Samuel Courtauld Trust)
D.1981.XX.3

PROVENANCE unknown

An active draughtsman in a variety of different media, Gauguin made detailed studies of the inhabitants, fauna and flora of Tahiti, as well as compositional sketches for his paintings. He spent a lot of time drawing, both for inspiration and while waiting for painting supplies to arrive from France. The recto of this sheet represents two studies of the head of a bearded man in profile. Gauguin applied the red chalk quite roughly, vigorously pressing it on to the paper. While it is tempting to speculate that they are self-portraits, the flattened, bulbous nose in the larger study differs from Gauguin's characteristic aquiline nose – the 'Inca profile' of which he was so proud.

The two Tahitian women on the verso are wrapped in bright pareos, which were increasingly abandoned with the growth of colonisation. The artist outlined his figures in graphite but used gouache diluted with water for the flesh and clothing. He seems to have tested different gouache colours first on the recto, in the upper right hand corner. Gauguin was particularly fond of this medium and used it to experiment with effects he sought to replicate in his oil paintings, superimposing layers of colour to capture areas of light and shadow.

This drawing comes from one of Gauguin's many sketchbooks that has been dismantled: the tear marks from the spine on the left are visible. Its sheets were numbered and sold off individually. The P.G. stamp in the lower right hand corner is probably not a studio stamp but may have been added by an early collector or dealer (Lugt 2078).

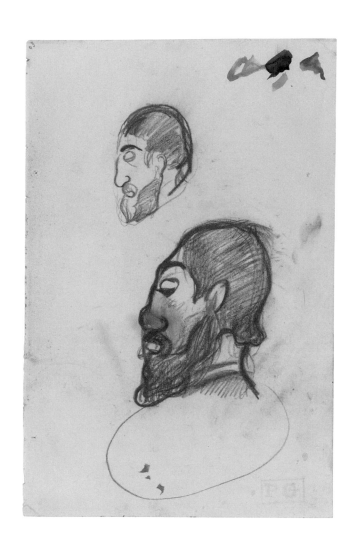

18

Standing Tahitian woman (recto) and Study of the head and torso of a man, viewed from the rear (verso), c. 1891–96

Graphite on paper, 27.75 x 17.8 cm
INSCRIPTIONS [upper left-hand corner of recto, in graphite] *60*;
[lower right-hand corner of recto, stamped in blue ink] *P.G.*
The Courtauld Gallery, London (Samuel Courtauld Trust)
D.1981.XX.2

PROVENANCE unknown

Gauguin complained about the difficulty of finding models in Tahiti but he was evidently sometimes successful. Here, the nude Tahitian woman is drawn from life and her silhouette carefully rendered. She extends the full length of the page and the artist has made additional studies of her feet on the right. She is accompanied by a small dog, depicted both frontally and in profile with a few assured strokes of a sharp pencil. The drawing of the standing woman is squared (meaning that a grid has been drawn over it), a typical method for transferring drawings on to another support while retaining the proportions.

The study of a man seen from the rear on the verso is also taken from life and was used by Gauguin in a later painting, *Three Tahitians*, executed in 1899. A drawing from the same sketchbook and bearing the number 63, on the art market with Colnaghi's in 2000, relates to Gauguin's *Nave Nave Mahana* (Musée des Beaux-Arts, Lyon), an oil painting dated 1896. It thus provides an end date for this section of the sketchbook. It is clear that Gauguin found in his studies a continuous source of inspiration and returned to them over the years.

This drawing probably comes from the same sketchbook as cat. 17: it is the same size, shows similar tears on the left edge and bears the P.G. mark.

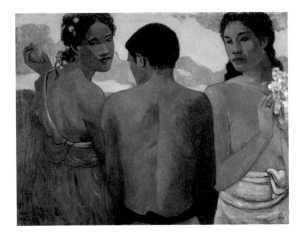

13 Paul Gauguin, *Three Tahitians*, 1899, oil on canvas, National Galleries of Scotland, Edinburgh

19

Poster for the First Post-Impressionist Exhibition, 1910

Attributed to Roger Fry (1866–1934)
Halftone print, 76.3 x 50.9 cm
The Courtauld Gallery, London (Samuel Courtauld Trust)
G.1958.PD.1

PROVENANCE gift of Roger Fry's daughter, Mrs Pamela Diamand, 1958

In the early 1910s, at the same moment he was curating his Post-Impressionist exhibitions, the curator, critic and artist Roger Fry founded the Omega Workshops, an artists' collective that sought to erase the line between the fine and decorative arts in everyday life. The Omega artists designed furniture, textiles and murals throughout the following decade. Acutely aware of the power of advertisement to deliver a visual message in an instant, they also created billboards and posters, including the one for the Second Post-Impressionist exhibition in 1912, a collaboration between Fry and close friends Vanessa Bell and Duncan Grant. Given the time constraints surrounding the First Post-Impressionist Exhibition in 1910, it is likely, however, that Fry was solely responsible for the design of this poster. It features elegant uppercase lettering alongside an image of Gauguin's *Poèmes barbares* (1896, Fogg Art Museum, Cambridge, MA). A caption below the image indicates that the photograph of this painting was taken by the Parisian dealer Eugène Druet, who had perfected a type of photographic process able to render faithfully the tonal subtleties of works of art. His photographs played an important part in publicising the work of Vincent van Gogh, among others. In a strange twist, however, it is unlikely that *Poèmes barbares* travelled to London: it cannot be linked to an entry in the catalogue nor is it mentioned in the press. It may have been promised by Druet but unable to travel in the end. Nevertheless, the image perfectly encapsulated Fry's vision for the exhibition, a move away from the representation of modern life championed by the Impressionists. The term 'Post-Impressionist' was coined for the Grafton Galleries exhibition and appears for the first time on this poster. It was hastily chosen by Fry to designate "a group of artists who cannot be defined by any single term", as the preface to the catalogue cautioned. In Fry's mind, however, they shared a common impulse to look beyond nature to find the essence of representation.

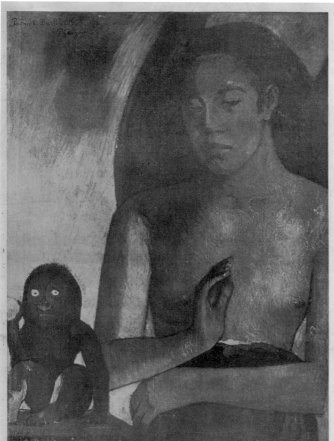

MANET
CEZANNE
GAUGUIN
VANGOGH
MATISSE
&
NOV· 8
TO
JAN· 15·

GRAFTON·GALLERY
MANET AND THE
POST·IMPRESSIONISTS

Letter from Roger Fry to Samuel Courtauld, 22 March 1929

Hotel de Londres
3 rue Bonaparte
Paris VIᵉ. Mar.22.'29.

My dear Courtauld

I don't know by what mistake I had got it into my head that the Gardanne [by Cézanne] was at [the dealer Paul] Guillaume's seeing how unlikely that was. I guessed before your wire came and went yesterday to see it. I knew the photograph of it by heart but had no idea of the colour. It was a great surprise to me when I saw it the colour being so unusual in some ways for Cézanne. It is franker stronger more positive in its contrasts than was usual in his landscapes though of course he [knows?] such schemes well in his still-lifes. It is certainly one of the most immediately arresting pictures that he ever did, at once monumental and decorative. [verso] It is altogether a most magnificent thing and stands almost in a class by itself. It is as though for once Cézanne had seized his idea more directly, more immediately, with less hesitation, than usual. I was at first a little disquieted by the cracks in the surface of the sky. I had it out of its frame and then realized that it was relined. This reassured me because I think the cracks were probably done to [sic] Cézanne's bad treatment of his own canvasses, letting them be rolled up and squashed and that there is no reason to fear, now that the impasto has been thoroughly fixed on its new canvas, that it will go any further. There were no signs of recent movement at all. I mean to go to [the dealer Paul] Rosenberg's again and get a second impression of the picture. I believe it will gain even on the great impression which a first sight made.

While I was there Rosenberg showed me a number of other interesting things which [p.2] you have probably seen—a superb still life of two fruits by Manet, much better than most of his still-lifes which I am not often enthusiastic about, and a huge Gauguin of two seated Tahitian girls in a room. This was an absolute revelation to me of what Gauguin was capable of. Gauguin has not maintained with me the prestige he had in the early days but this seemed to me to show that after all there was something very big about him. I gathered that R. was asking

58

a colossal price though he didn't tell me what. Is it worth your while your considering selling your Nevermore and getting this, which is I suspect <u>the</u> masterpiece of Gauguin? I only wonder whether you have thought of this. Probably you have and decided against it.

I hope to get south shortly but shall be back in late spring.

Yours very sincerely,

Roger Fry

Letter from Roger Fry to Samuel Courtauld, 28 March 1929

Hotel de Londres
3 rue Bonaparte
Paris .VI. Mar.28.'29.

My dear Courtauld,

I went again to Rosenberg's to day to get a second impression of the Cézanne though it's very difficult with Rosenberg at hand with all his intolerable <u>boniments</u>. Why are the German dealers so much nicer than the French? I hate the atmosphere of the rue de la Boetie.

On a second impression I found that it seemed to have gained in amplitude that I realized better the immense stillness and poise of the whole design. [verso] Things that had struck me as a little summary seemed to take their place more inevitably in the general harmony. Of course the price you mention is enormous but I daresay it will seem small in twenty years' time if the world goes on as it is going. Only I think I would make that the limit, as far as I can judge of such very speculative matters. I think he would be foolish to stand out for more. It would be splendid if you could get both this and the Gauguin which I feel confident is his masterpiece. A collection like yours must aim at having everything of the finest possible quality, and indeed in Cézanne you are already well on to that end and in Renoir too for that matter.

I am leaving Paris to-morrow but letters will be forwarded from this address.

Yours very sincerely,

Roger Fry

BOOKS AND ARTICLES CITED

Clive Bell, *Old Friends. Personal Recollections*, London, 1956

Anne-Pascale Bruneau, 'Aux sources du post-impressionisme. Les expositions de 1910 et 1912 aux Grafton Galleries de Londres', *Revue de l'Art*, no. 113, 1996, pp. 7–18

J.B. Bullen (ed.), *Post-Impressionists in England: the Critical Reception*, London and New York, 1988

J.B. Bullen, 'Great British Gauguin. His reception in London in 1910–11', *Apollo*, vol. CLVIII, no. 500 (new series), October 2003, pp. 3–12

Isabelle Cahn, 'An echoing silence: the critical reception of Gauguin in France, 1903–49', *Van Gogh Museum Journal*, 2003, pp. 25–39, revised in 'Belated Recognition: Gauguin and France in the Twentieth Century, 1903–1949', in Boston, 2004, pp. 286–301

Douglas Cooper, *The Courtauld Collection. A Catalogue and Introduction*, London, 1954

Donald E. Gordon, *Modern Art Exhibitions, 1900–1916: Selected Catalogue Documentation*, 2 vols., Munich, 1974

Christopher Gray, *Sculpture and Ceramics of Paul Gauguin*, Baltimore, 1963

Anna Gruetzner Robins, '"Manet and the Post-Impressionists": a checklist of exhibits', *The Burlington Magazine*, vol. CLII, no. 1293, December 2010, pp. 782–93

Anna Gruetzner Robins, 'Marketing Post-Impressionism: Roger Fry's Commercial Exhibitions', in Pamela Fletcher and Anne Helmreich (eds.), *The Rise of the Modern Art Market in London, 1850–1939*, Manchester, 2011

Marcel Guérin, *L'Œuvre gravé de Gauguin*, 2 vols., Paris, 1927

Charlotte Hale, *A Study of Paul Gauguin's Correspondence Relating to his Painting Materials and Technique, with Specific Reference to his Works in the Courtauld Collection*, Diploma Project, Courtauld Institute of Art, University of London, 1983

Polly Hill and Richard Keynes eds, *Lydia and Maynard. Letters between Lydia Lopokova to John Maynard Keynes*, London, 1989

Charles Holmes, *Old Masters and Modern Art. The National Gallery. France and England*, London, 1927

Madeleine Korn, *Collecting Modern Foreign Art in Britain before the Second World War*, 3 vols., PhD thesis, University of Reading, 2001

Peter Kropmanns, 'The Gauguin exhibition in Weimar in 1905', *The Burlington Magazine*, vol. CXLI, no. 1150, January 1999, pp. 24–31

'London Letter (London, Nov. 9, 1910)', *American Art News*, vol. IX, no. 6, 19 November 1910, p. 5

Elizabeth Mongan, Eberhardt W. Kornfeld and Harold Joachim, *Paul Gauguin. Catalogue Raisonné of his Prints*, Bern, 1988

Charles Morice, *Paul Gauguin*, Paris, 1919

Benedict Nicolson, 'Post-Impressionism and Roger Fry', *The Burlington Magazine*, vol. XCIII, no. 574, January 1951, pp. 11–15

Michael Sadleir, *Michael Ernest Sadler 1861–1943. A Memoir by his Son*, London, 1949

Daniel Wildenstein, with Sylvie Crussard and Martine Heudron, *Gauguin. Premier itinéraire d'un sauvage. Catalogue de l'oeuvre peint (1873–1888)*, 2 vols., Paris, 2001

Georges Wildenstein, *Gauguin. I. Catalogue*, Paris, 1964

EXHIBITION CATALOGUES

Catalogue of the Pictures, Drawings, Prints and Sculptures in the Eighth Exhibition of the International Society of Sculptors, Painters and Gravers, New Gallery, London, 1908

Manet and the Post-Impressionists, Grafton Galleries, London 1910–11

Catalogue of the Pictures, Drawings and Sculpture of the French School of the Last Hundred Years, Burlington Fine Arts Club, London, 1922

Catalogue of an Exhibition of Works by Paul Gauguin (1848–1903), Leicester Galleries, London, 1924

The Art of Paul Gauguin, ed. Richard Brettell, Françoise Cachin, Claire Frèches-Thory and Charles F. Stuckley, National Gallery of Art, Washington DC, The Art Institute of Chicago and Grand Palais, Paris, 1988–89

Impressionism for England. Samuel Courtauld as Patron and cCollector, ed. John House, Courtauld Institute Galleries, London, 1994

Modern Art in Britain, 1910–1914, ed. Anna Gruetzner Robins, Barbican Art Gallery, London, 1997

The Private Collection of Edgar Degas, ed. Ann Dumas, Colta Ives, Susan Alyson Stein and Gary Tinterow, The Metropolitan Museum of Art, New York, 1997–98

Art Made Modern : Roger Fry's Vision of Art, ed. Christopher Green, Courtauld Gallery, London, 1999–2000

The Lure of the Exotic. Gauguin in New York Collections, ed. Colta Ives and Susan Alyson Stein, with Charlotte Hale and Marjorie Shelley, The Metropolitan Museum of Art, New York, 2002

Gauguin Tahiti, ed. Georges T. M. Shackelford and Claire Frèches-Thory, Galeries Nationales du Grand Palais, Paris and Museum of Fine Arts, Boston, 2003–04 [French edition published in 2003 as *Gauguin Tahiti. L'Atelier des tropiques* with slightly different catalogue numbers]

Gauguin's Vision, ed. Belinda Thomson, National Galleries of Scotland, Edinburgh, 2005

Van Gogh and Britain. Pioneer Collectors, ed. Martin Bailey, with Frances Fowle, National Galleries of Scotland, Edinburgh, 2006

Impressionism and Scotland, ed. Frances Fowle, National Galleries of Scotland, Edinburgh, 2008

The Courtauld Cézannes, ed. Stephanie Buck, John House, Ernst Vegelin van Claerbergen and Barnaby Wright, The Courtauld Gallery, London, 2008

Gauguin, Maker of Myth, ed. Belinda Thomson, Tate, London, and National Gallery of Art, Washington D.C., 2010–11